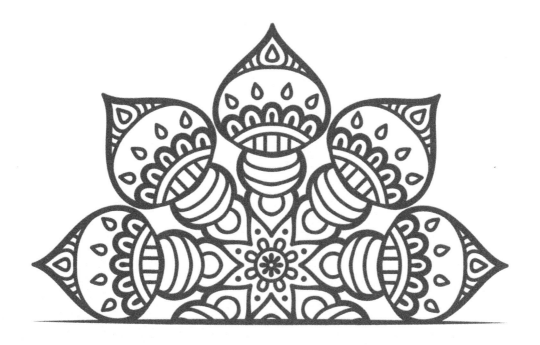

FIREFIGHTER
COLORING
BOOK

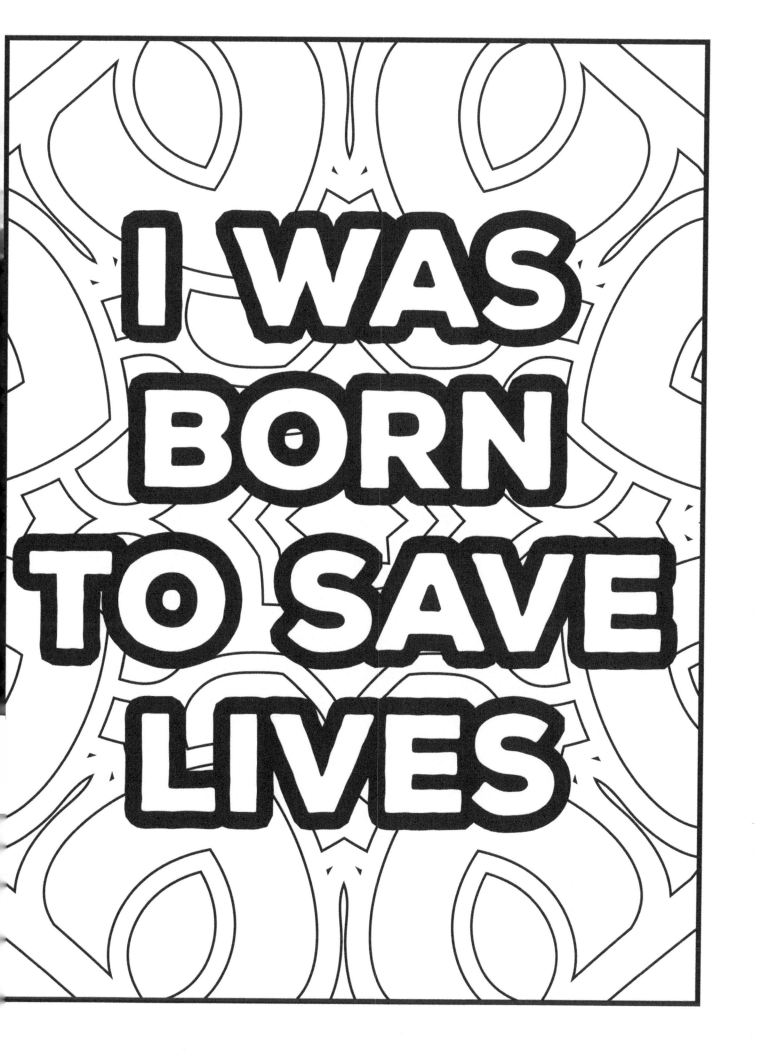

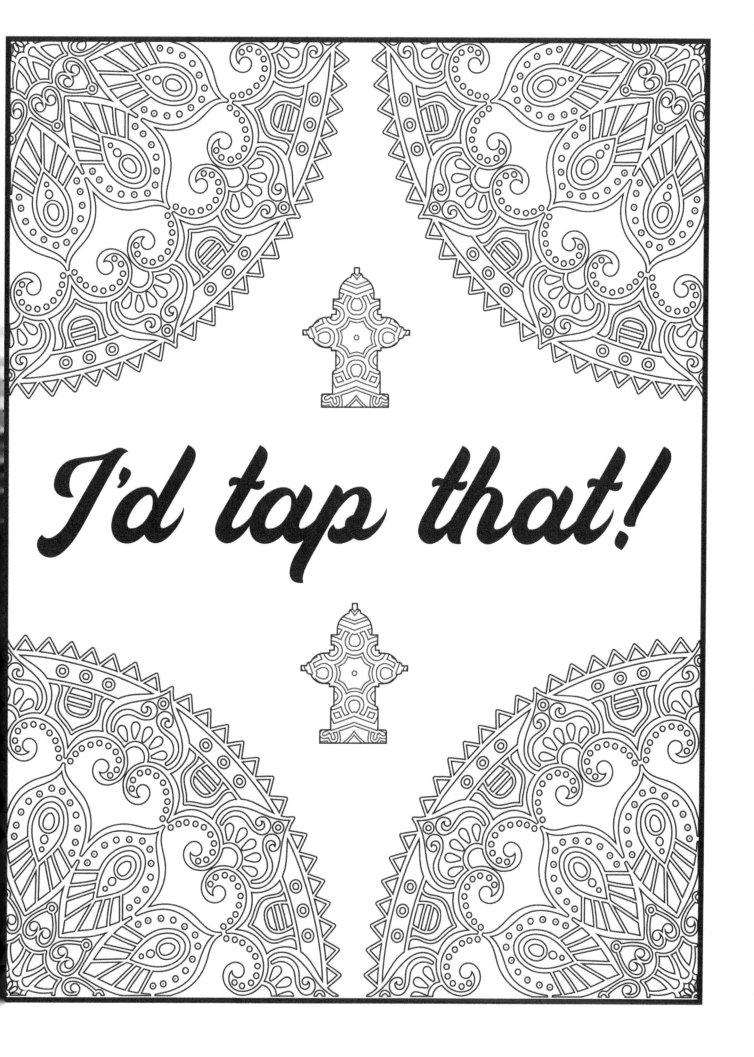

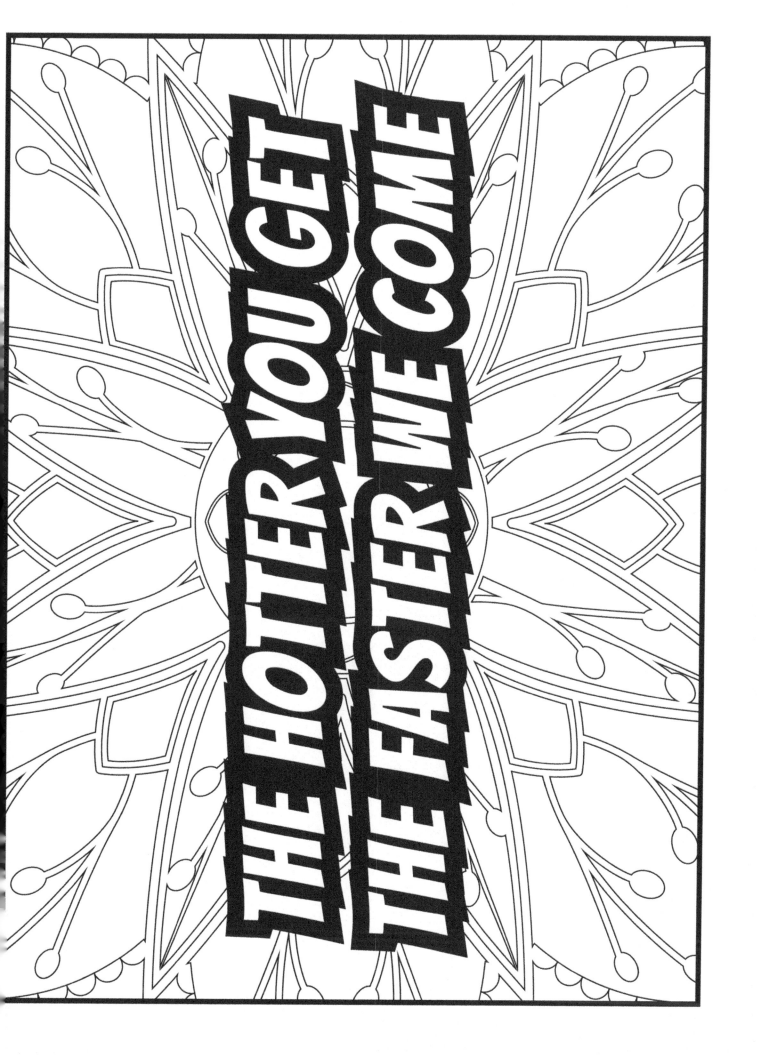

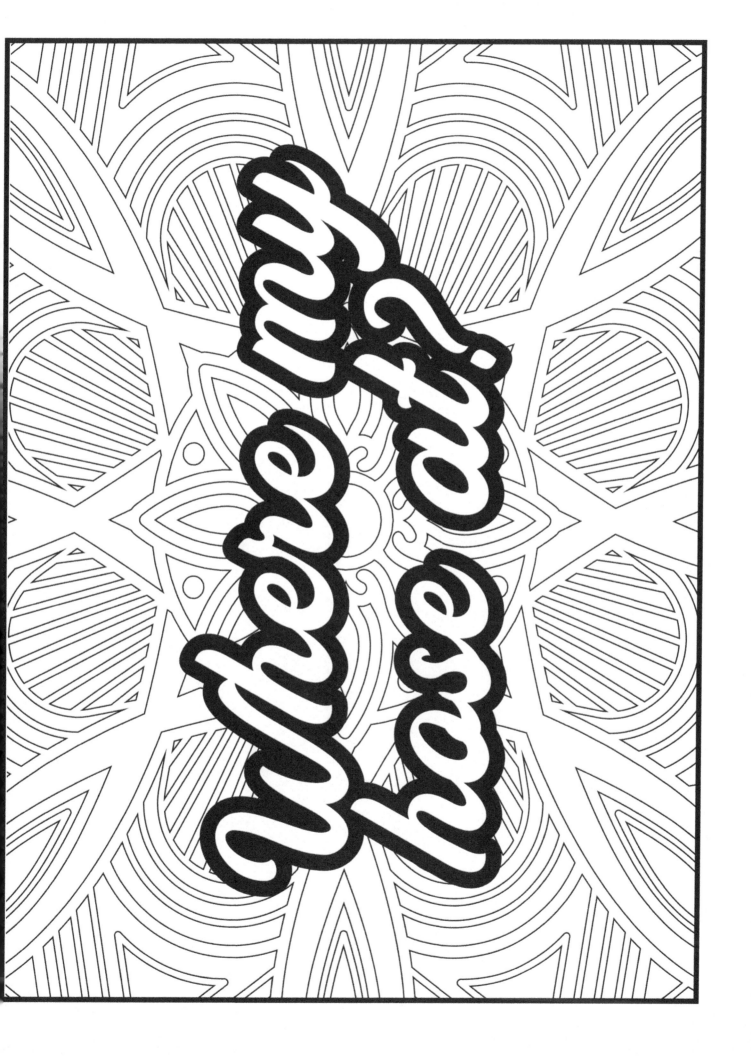

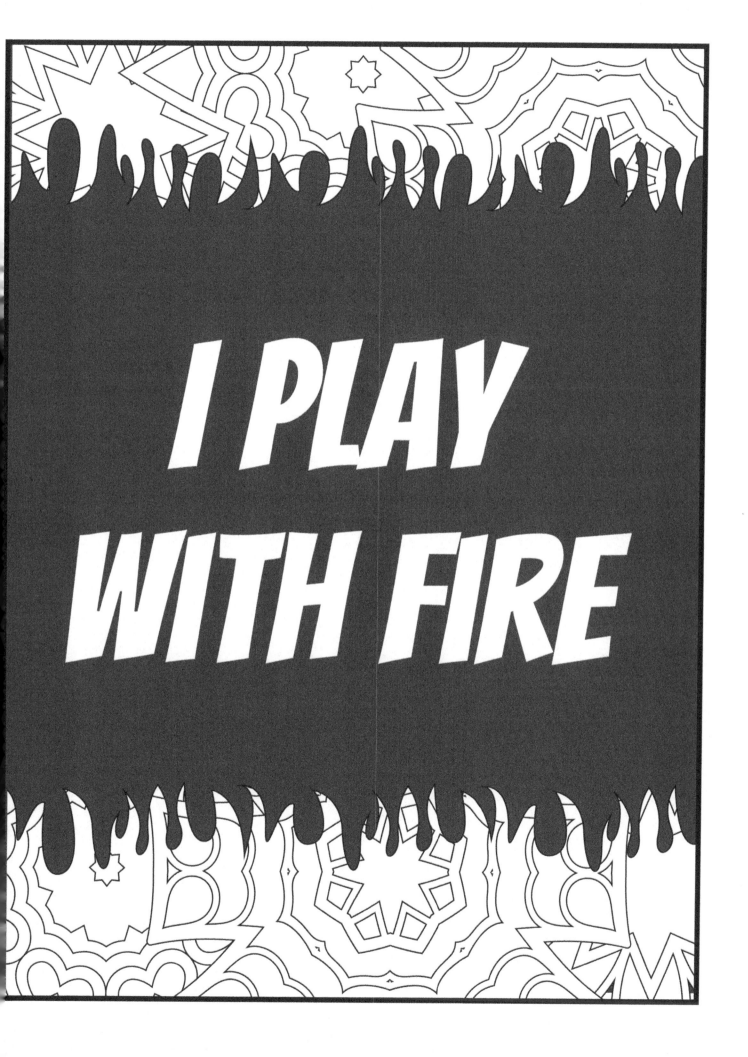

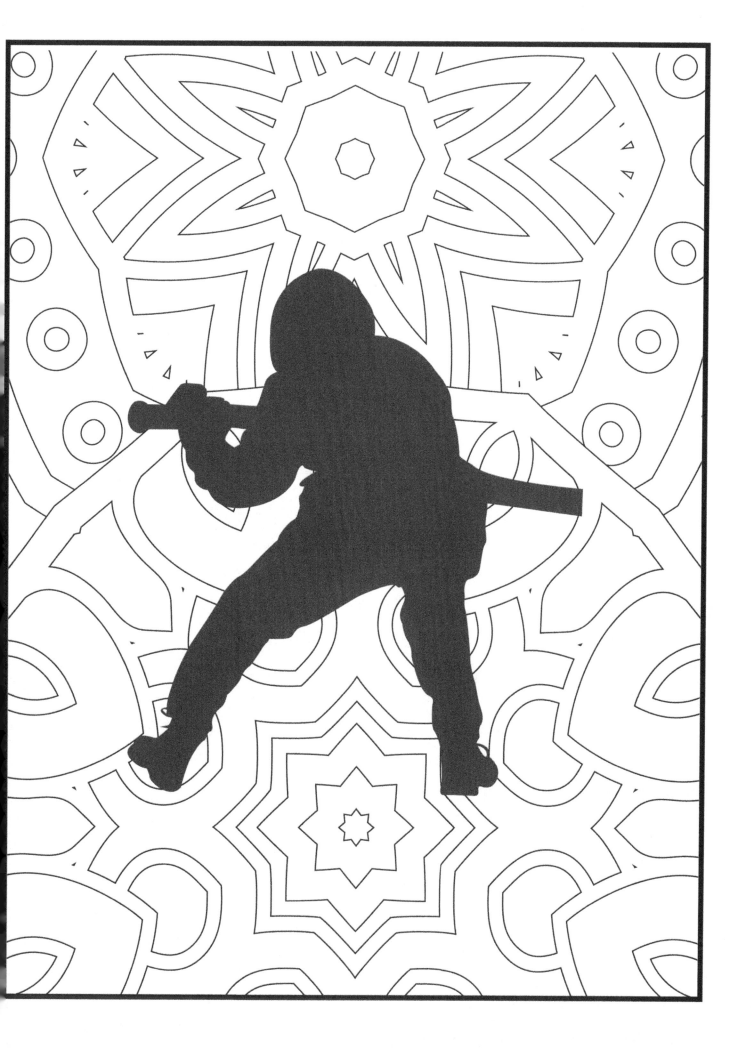

STRENGTH BEHIND THE BOOTS

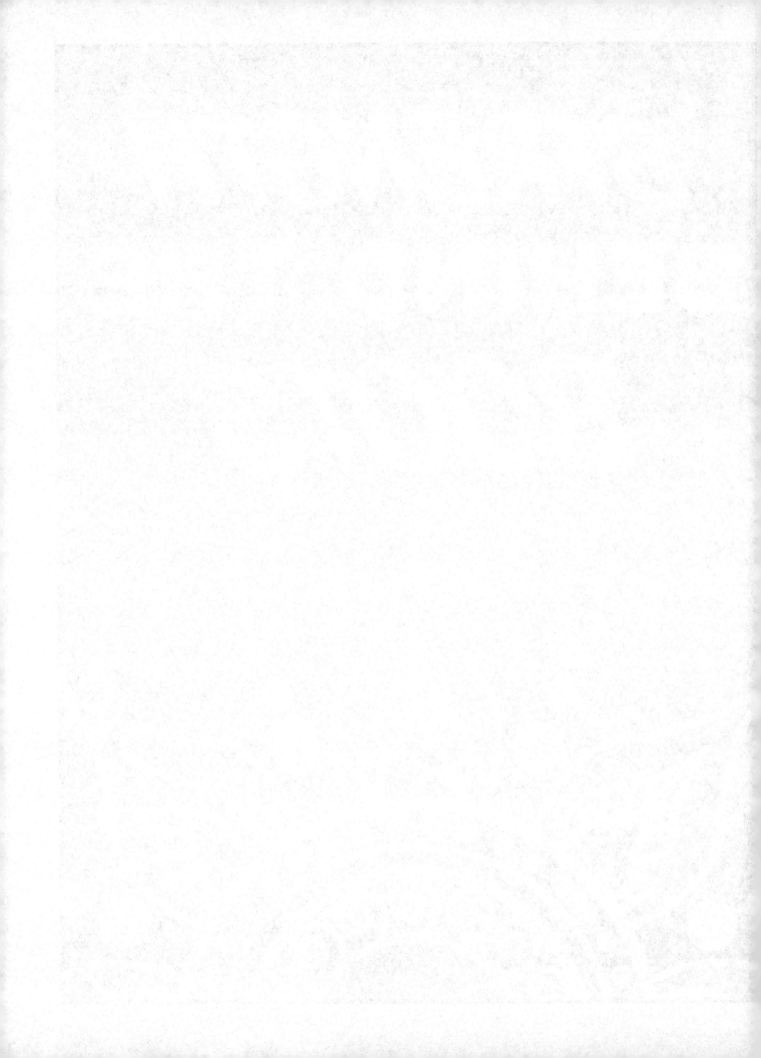

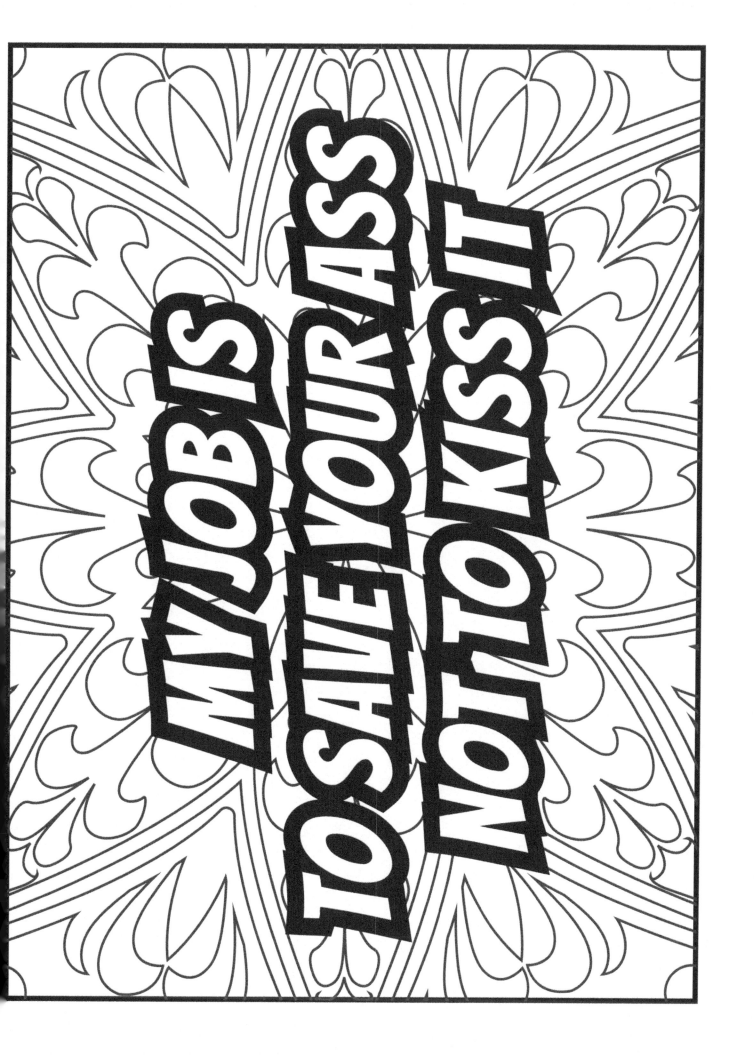

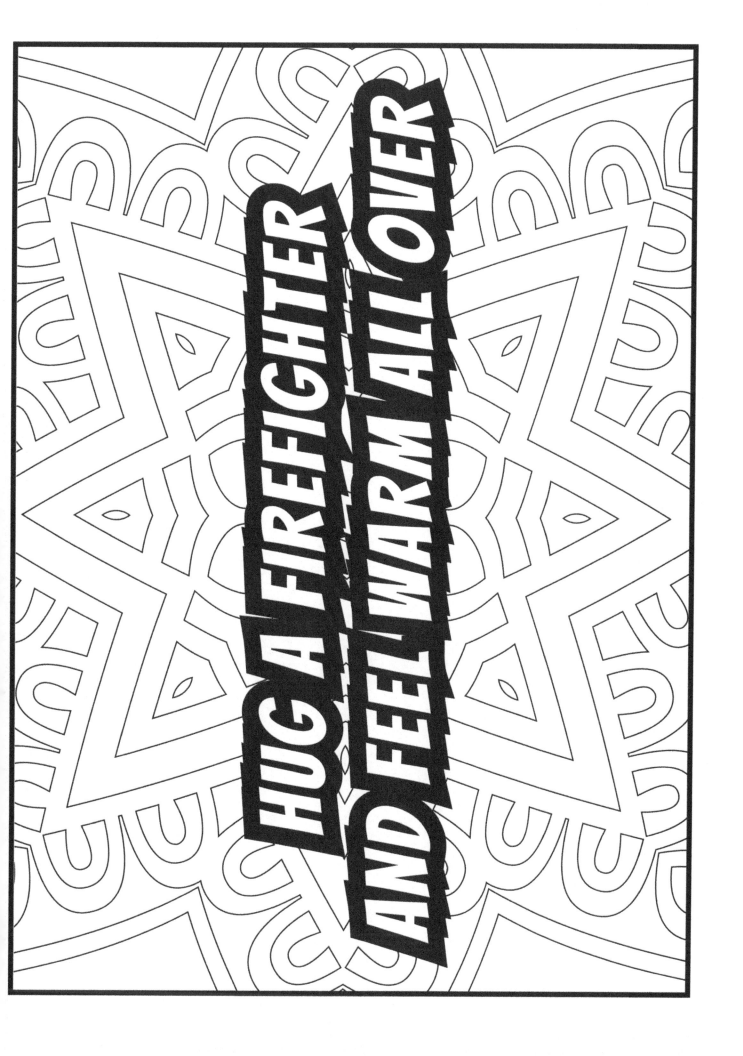

911 IS MY WORK NUMBER

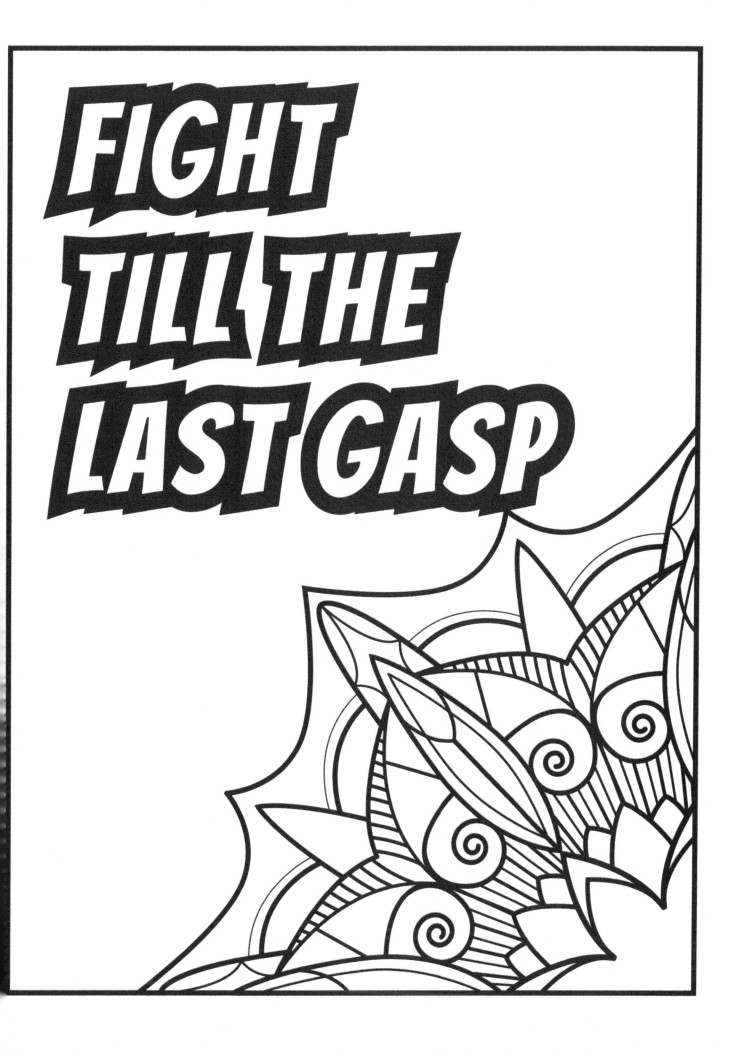

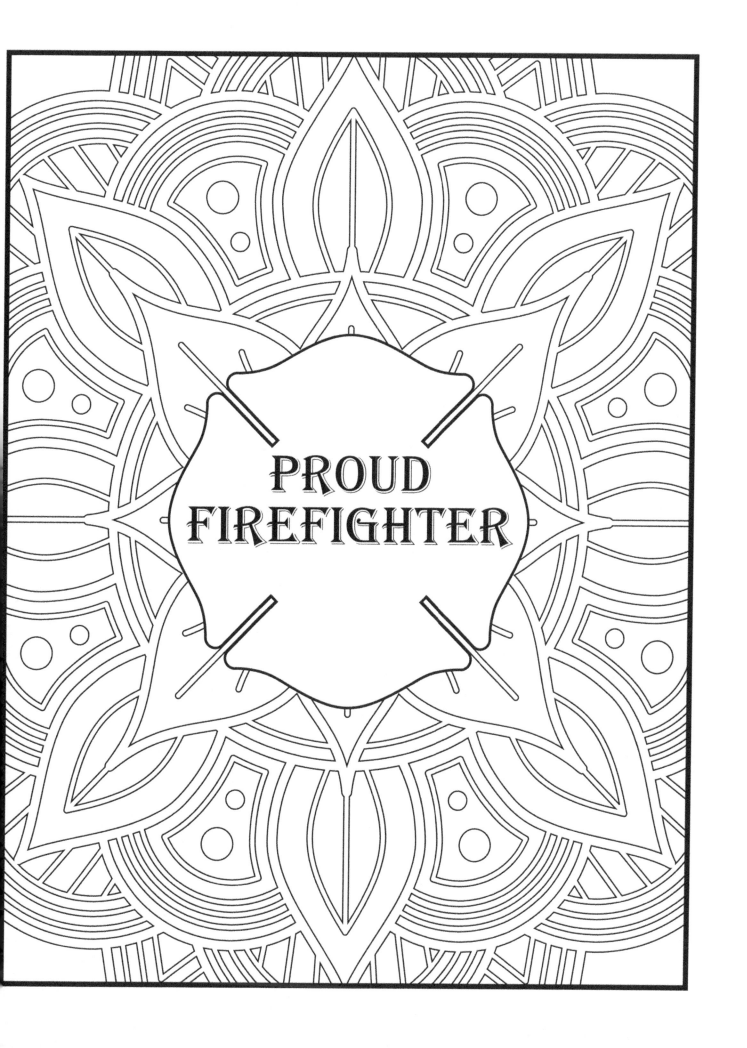

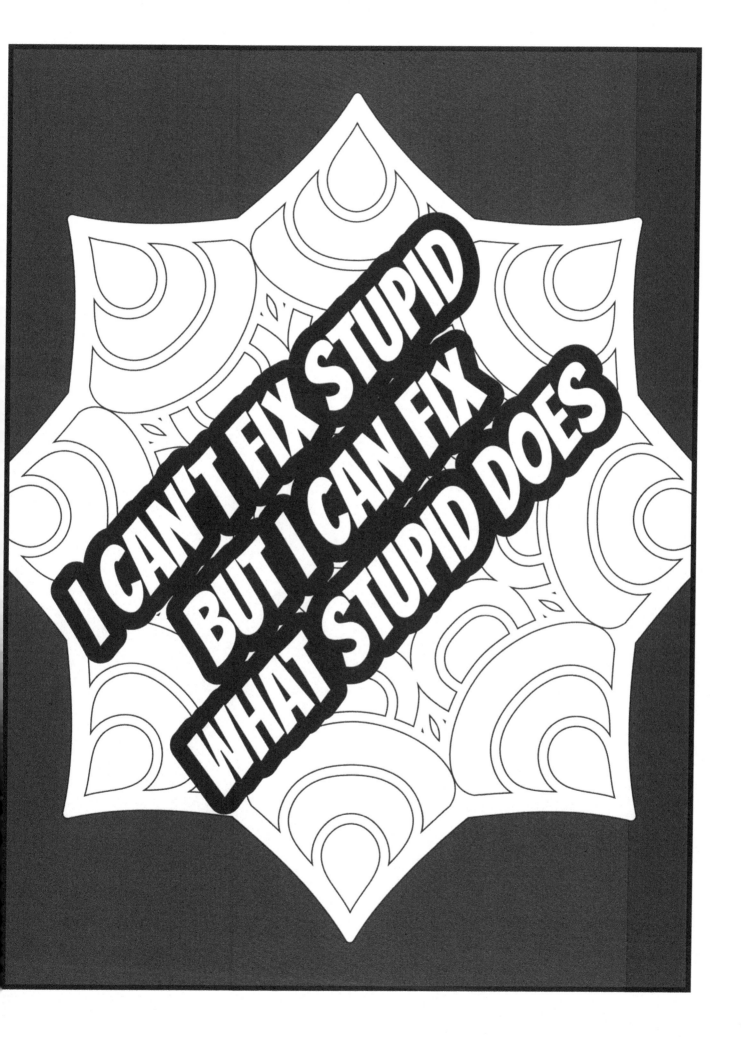

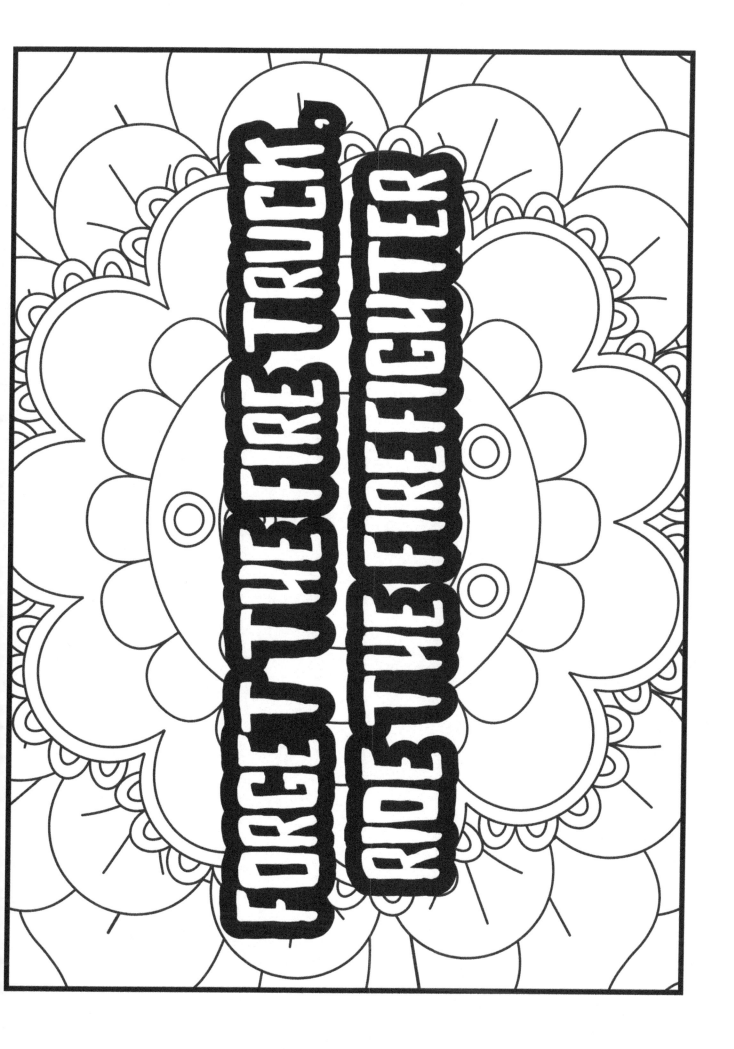

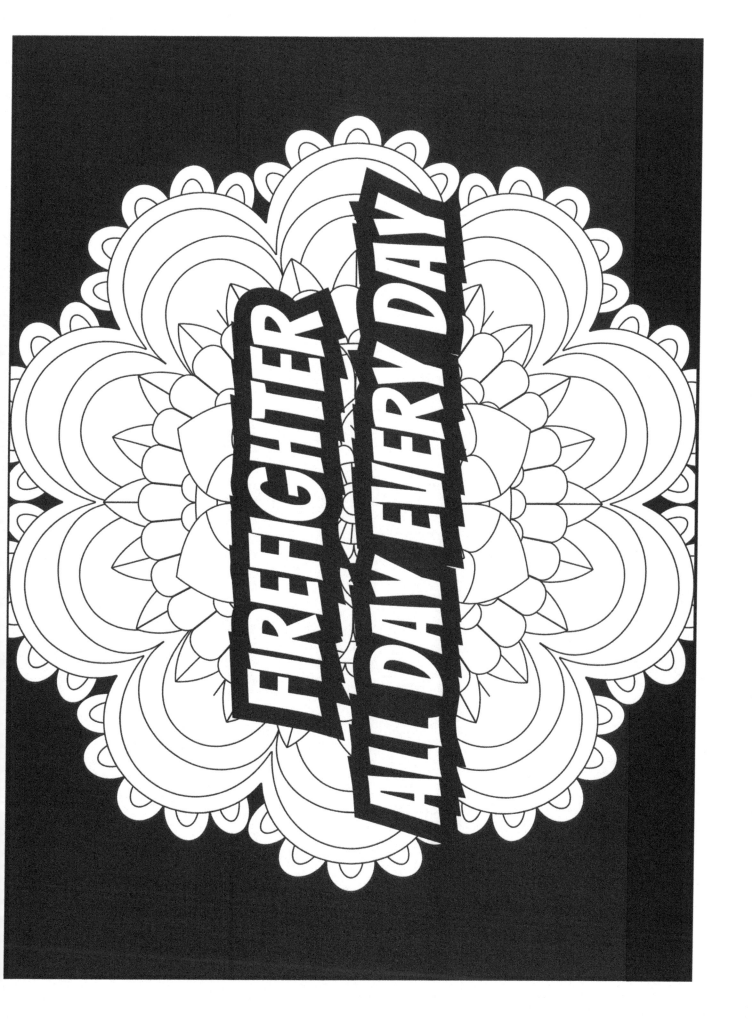

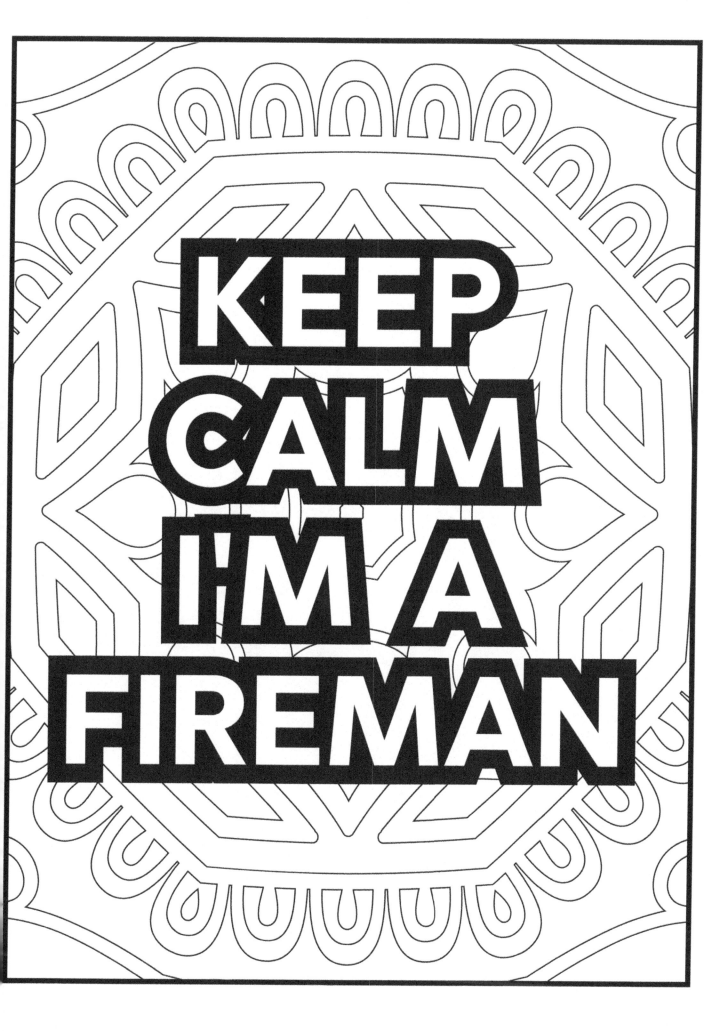

WHO NEEDS A SUPERHERO WHEN YOU'RE A FIREFIGHTER

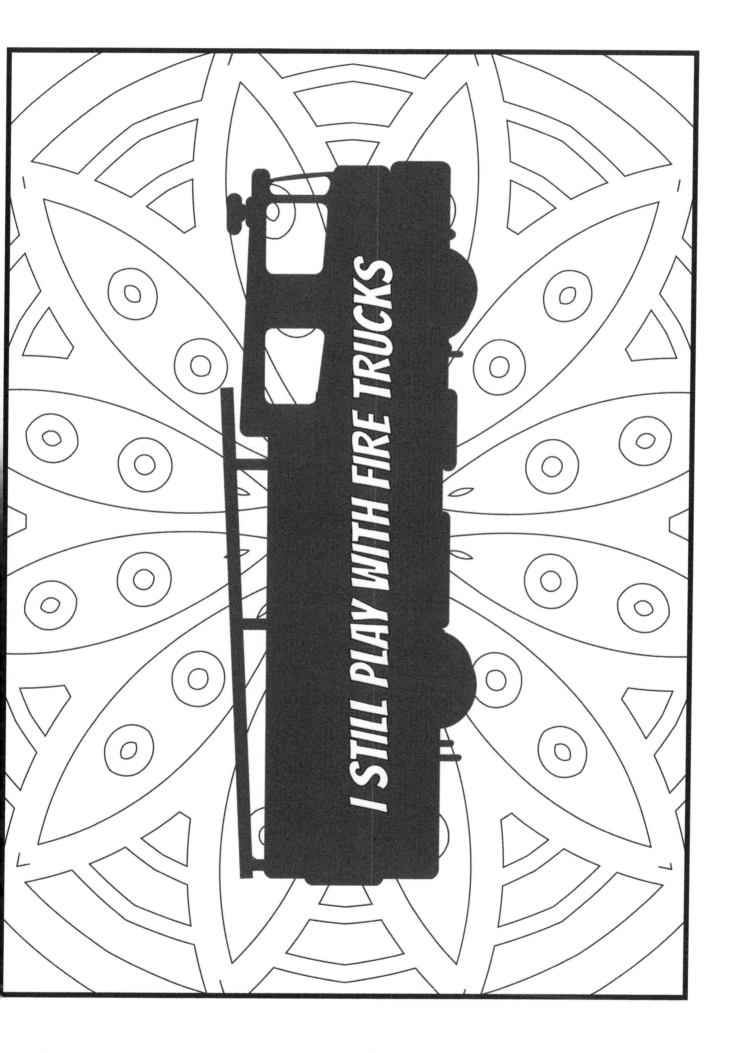

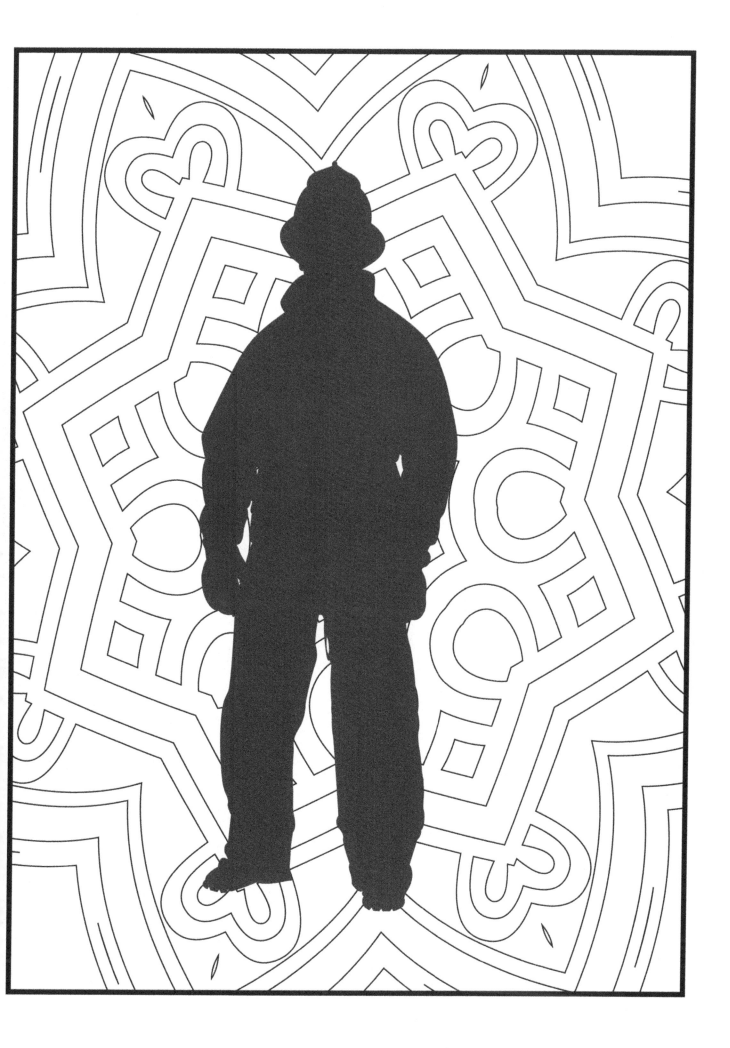

THE BEST FIREFIGHTER EVER

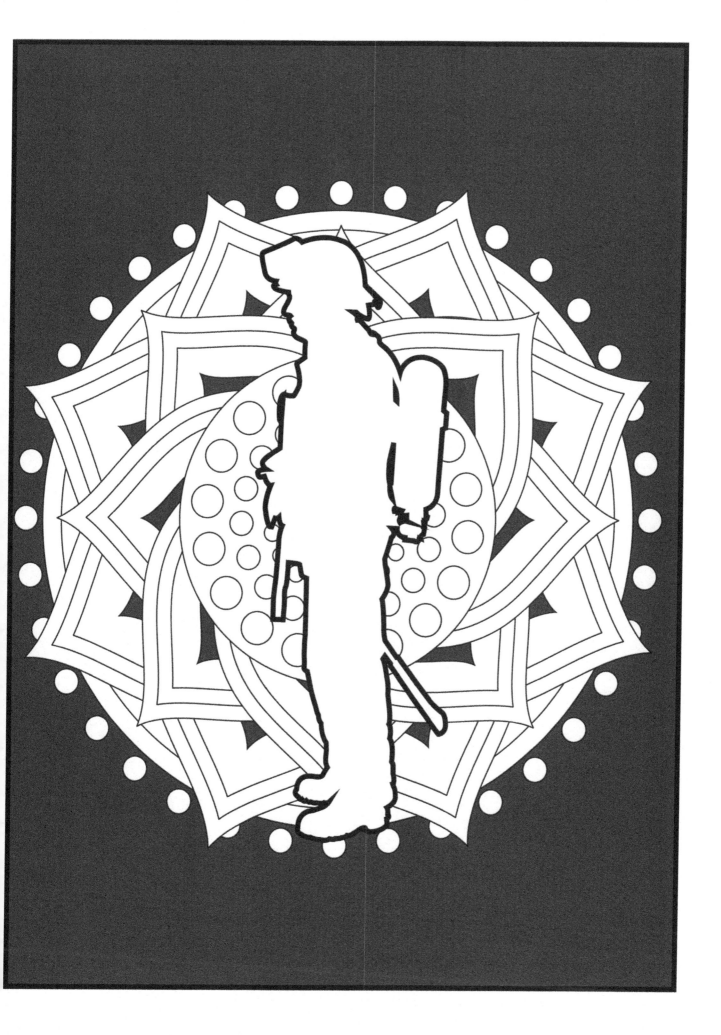

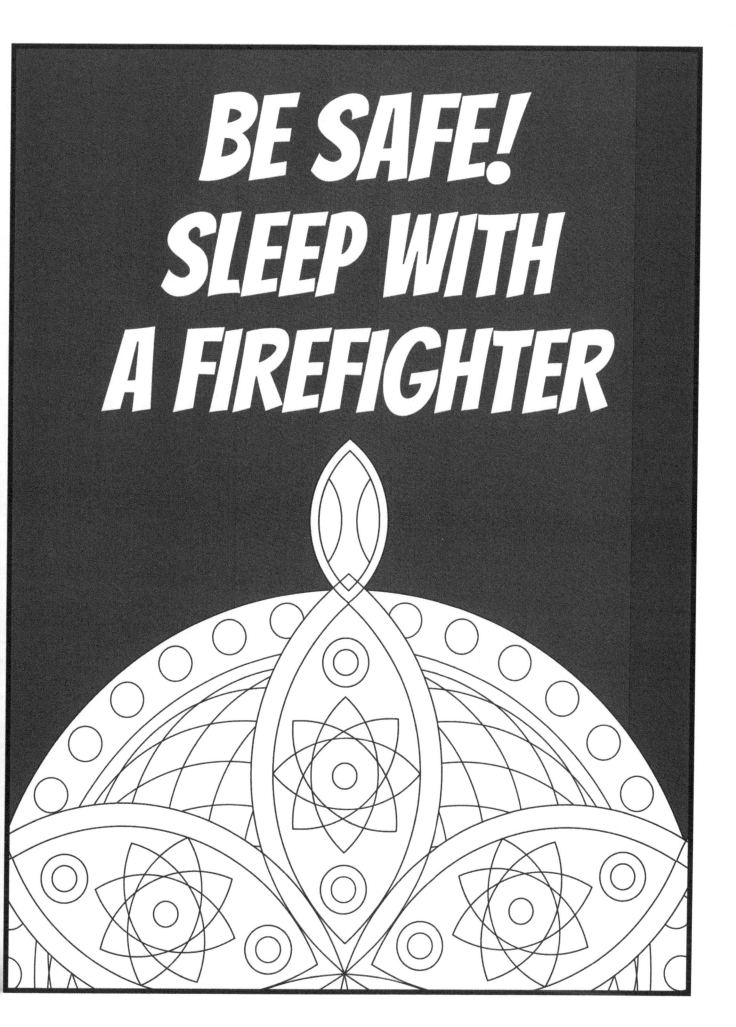

Happiness is sliding up and down a fireman's pole

Made in the USA
Coppell, TX
27 August 2020